# Bolt AND Keel

## THE WILD ADVENTURES OF TWO RESCUED CATS

Kayleen VanderRee & Danielle Gumbley

THE COUNTRYMAN PRESS

A division of W. W. Norton & Company

*Independent Publishers Since 1923*

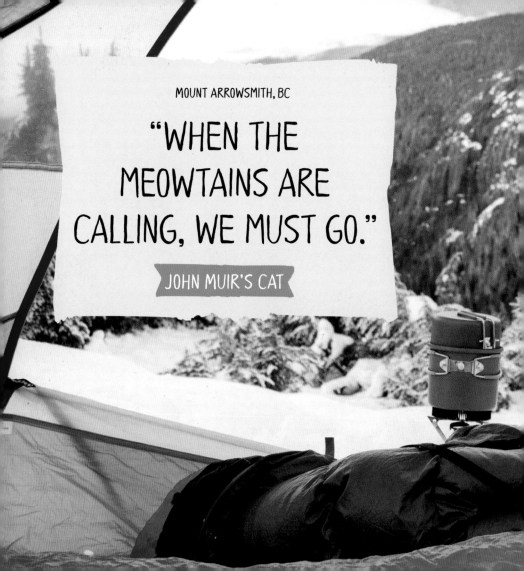

MOUNT ARROWSMITH, BC

"WHEN THE MEOWTAINS ARE CALLING, WE MUST GO."

JOHN MUIR'S CAT

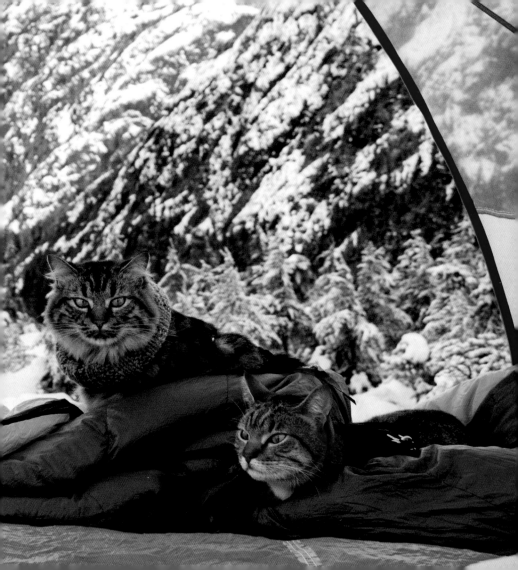

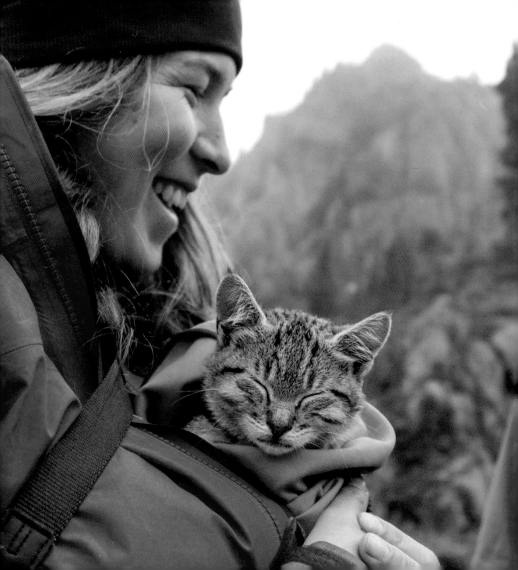

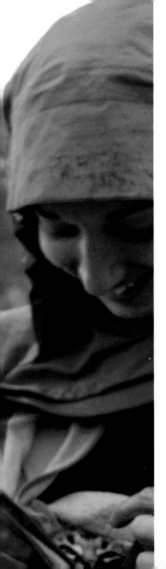

# Introduction

While working as leaders at a camp one summer, we found two kittens behind a trash can at a local park. We had 20 children gazing up at us with pleading eyes and two tiny kittens who were in need of a home. The next day we had plans to leave on a multi-day trek into the mountains of Canada's Vancouver Island. We tried to take the cats to the shelter after work, but it was closed by the time we got there. With no other choice, at a month old, Bolt and Keel found themselves on their first adventure. After a short canoe ride, we tucked the kittens into our jackets and started up a series of switchbacks. Bolt and Keel's curious natures took over; they leaped from the safety of our

MARBLE MEADOWS, BC, AT ONE MONTH OLD

jackets without fear. Their tiny harnesses and leashes kept them close as they embarked alongside us on their first grand journey. We quickly found ourselves falling in love with the idea of bringing Bolt and Keel with us wherever we went. By Sunday evening, we knew we wouldn't be taking them to the shelter.

A few months later, we shared our photos of their escapades on social media. Overnight, the story of Bolt and Keel went viral, and their following has grown steadily ever since. Bolt and Keel are on the forefront of the growing adventure cat movement, daily breaking house cat stereotypes with their strong personalities and intrepid pursuit of adventure.

Bolt and Keel now regularly join us on backpacking, canoeing, kayaking, and hiking adventures. Their explorations have taken them around Vancouver Island, British Columbia, and even into Washington State. As the cats get braver and their expedi-

tions become more adventurous, we have ensured that they are properly equipped for their outings. Harnesses and leashes are always a must, life jackets are donned, and they even wear sweaters and jackets on those damp days. However, the most important thing to be aware of when taking cats into the wilderness is being able to read their body language and to be in tune with their needs. Just like anyone else, Bolt and Keel have their good days and bad days—when their moods don't cooperate or the weather takes a turn for the worst. But no matter what, there is nothing like hiking at a cat's pace to change your purrspective and make you appreciate the trail in a new way.

Enjoy!

## KAYLEEN AND DANIELLE

P.S. KEEP UP WITH BOLT AND KEEL'S LATEST ADVENTURES ON INSTAGRAM @BOLTANDKEEL

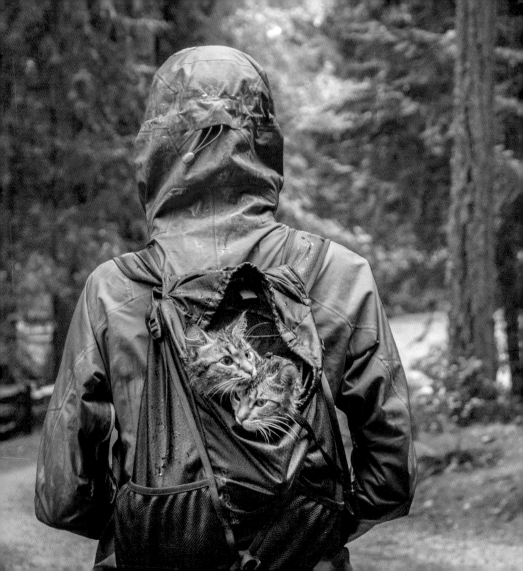

Bolt and Keel quickly learned not to let inclement West Coast weather slow them down. A few months old, they braved the rain to attempt their first mountain.

They learned that it is not always about getting to the top. . . .

MOUNT MANUEL QUIMPER, BC

. . . The road there is
just as enjoyable.

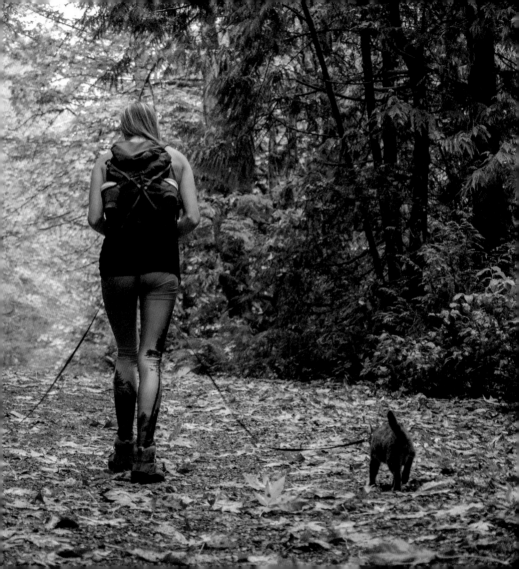

As soon as the car door opens, Bolt and Keel are eager to hit the trail.

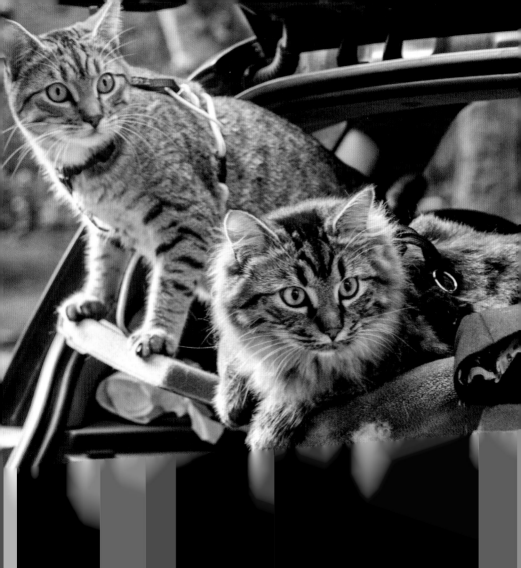

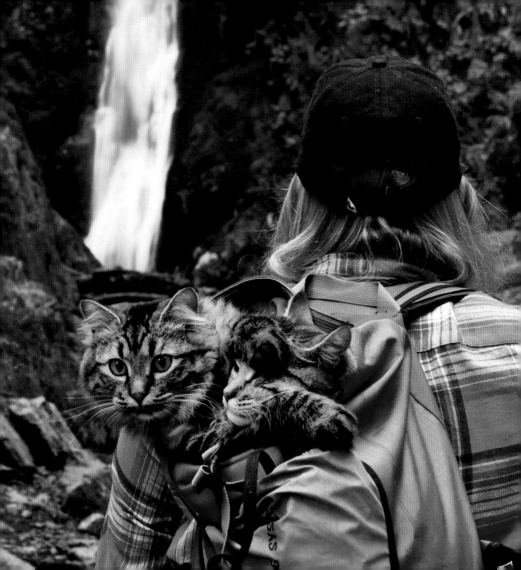

# "DON'T WORRY BRO, I'VE GOT YOU."

BOLT

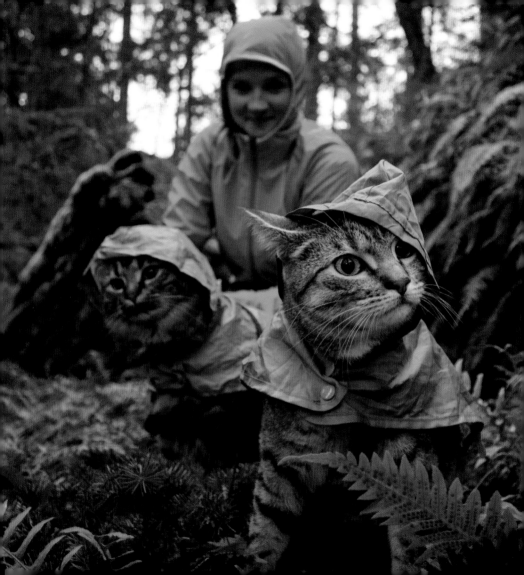

# Matching jackets on point.
## #SquadGoals

Most cats fear water, but Bolt and Keel have never been "most cats." Their first kayak outing was a sunny success.

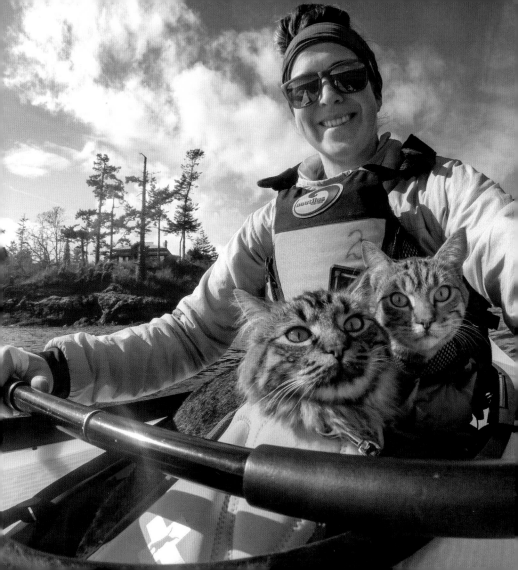

SALISH SEA, BC

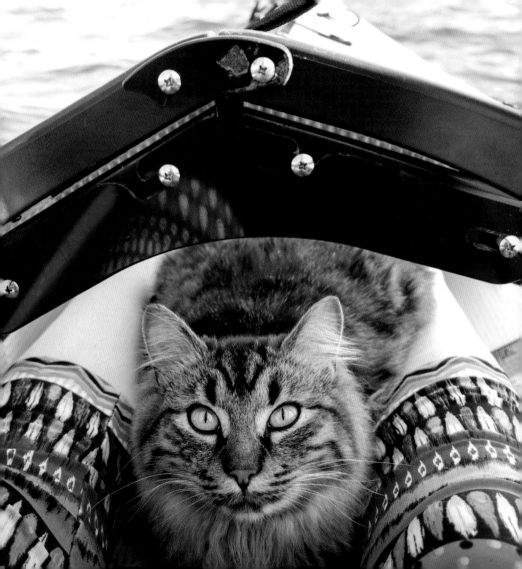

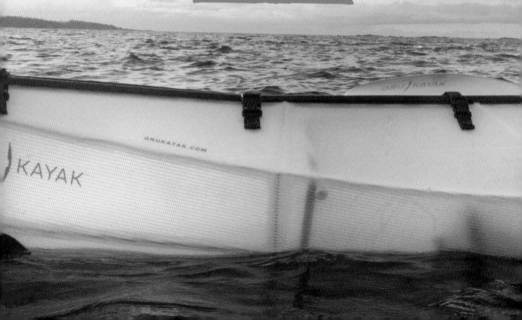

"I MAY BE FURROCIOUS, BUT I'M NOT A TIGER."

BOLT, ON *LIFE OF PI*

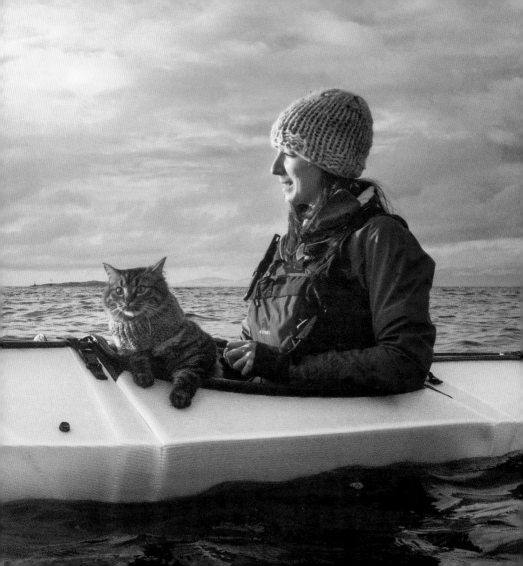

Bolt and Keel spent four days hiking and canoeing British Columbia's Sunshine Coast. It was their biggest adventure yet.

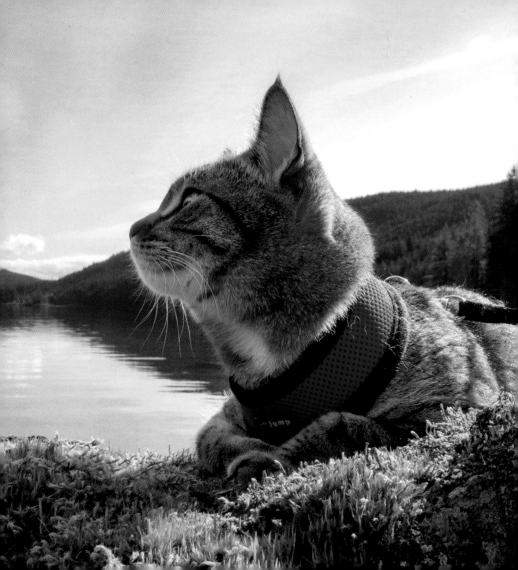

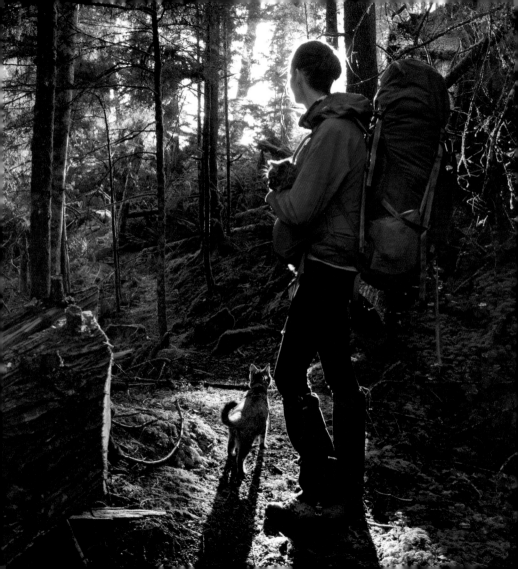

The Sunshine Coast Trail stretches 100 miles; Bolt and Keel completed a portion of the trail, including 6 miles on their own four paws.

# Fact:
## fed cat = happy cat

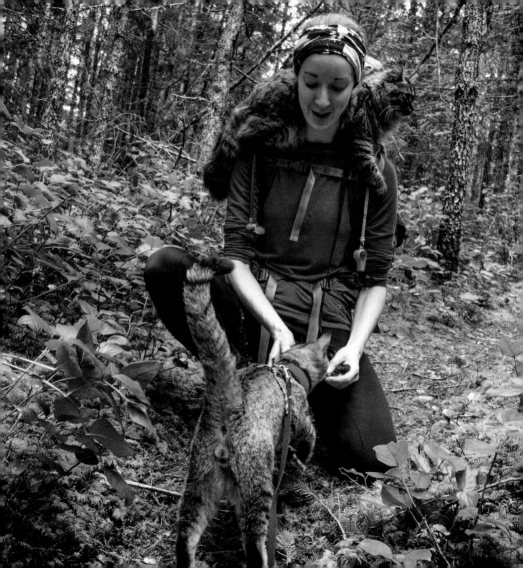

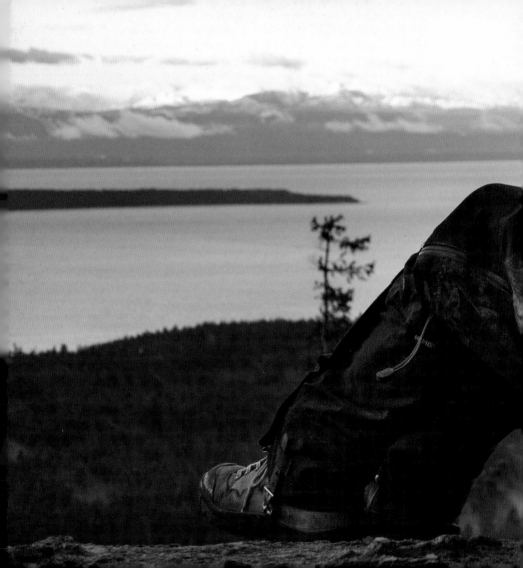

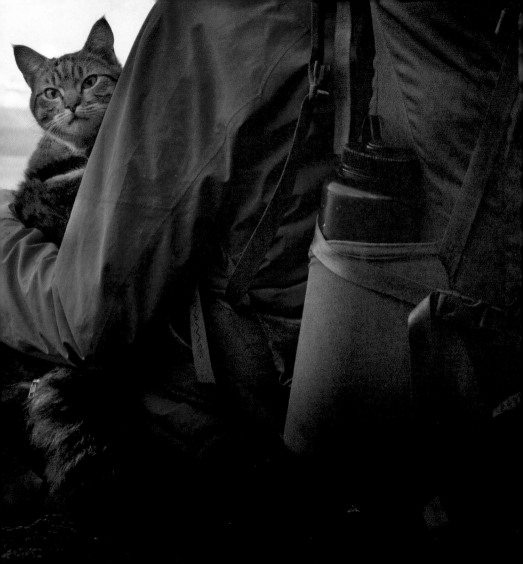

"WIND IN MY WHISKERS, SUN WARMING MY FUR—I COULD GET USED TO THIS THING THEY CALL CANOEING."

BOLT

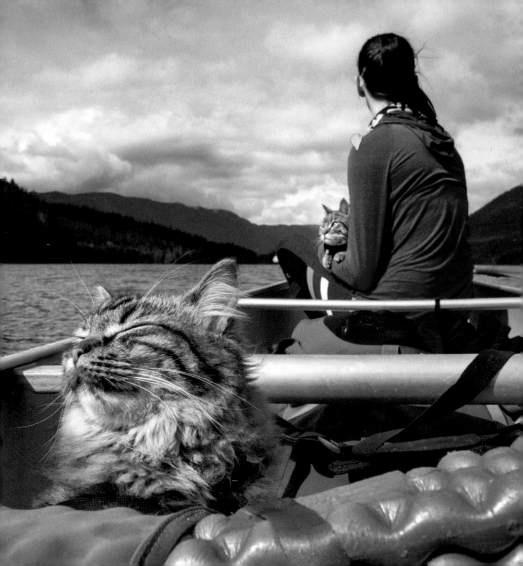

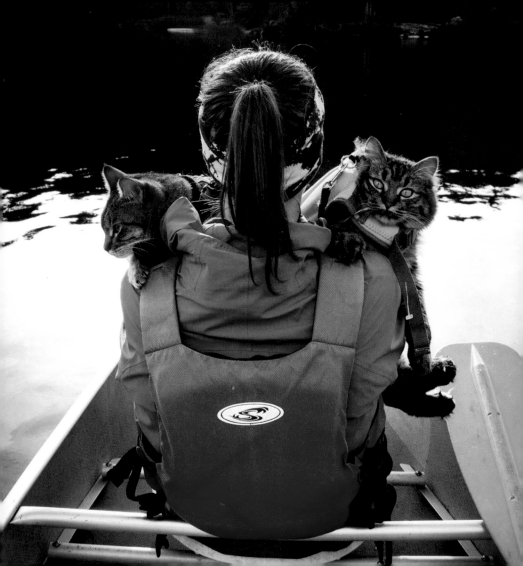

A sunset, canoe, and
your best buddies—
what more could you need?

Adventuring with Bolt
and Keel is a good reminder
to slow down and enjoy the
moments that often drift by.

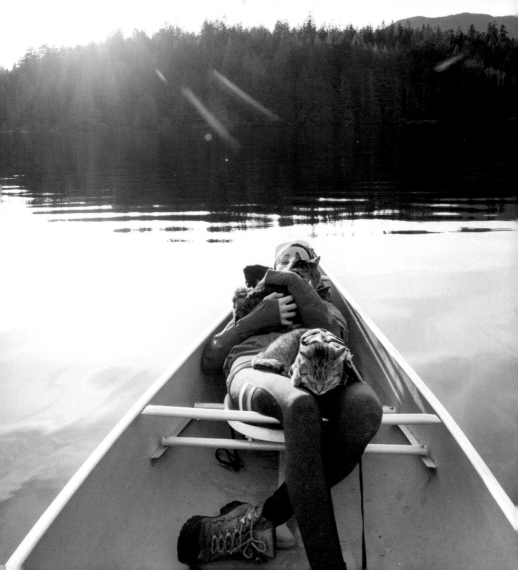

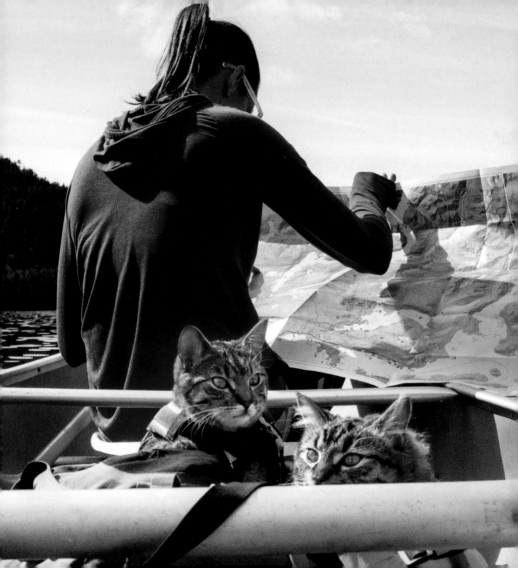

# "YOU'VE GOT TO BE KITTEN ME . . . WE'RE LOST AGAIN?"

KEEL

INLAND LAKE, BC

Giving Columbus
a run for his money.

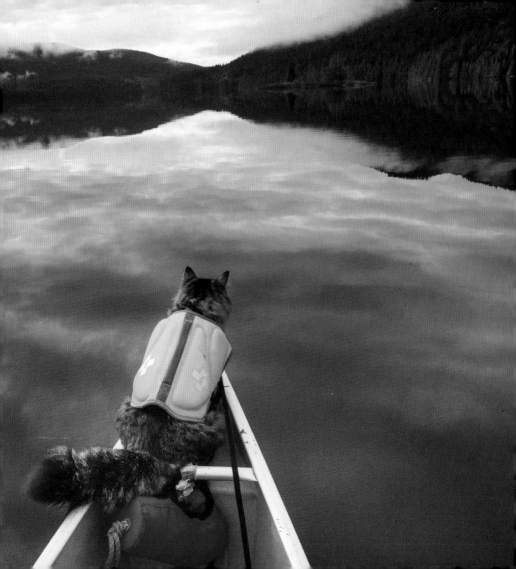

INLAND LAKE, BC

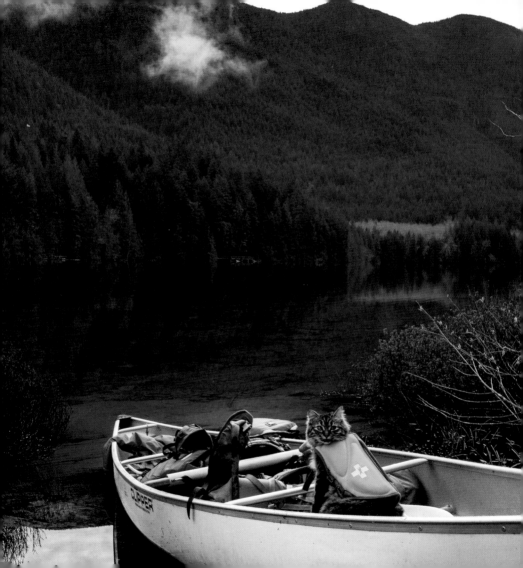

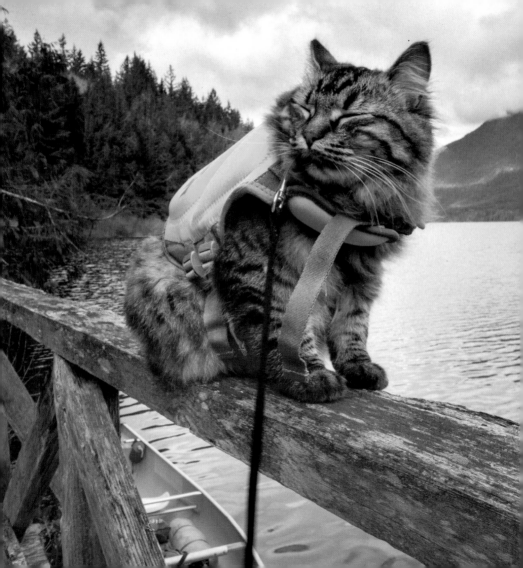

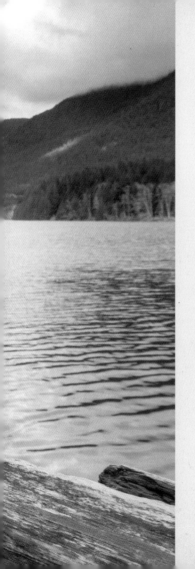

INLAND LAKE, BC

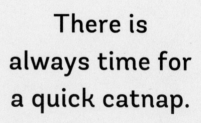
There is
always time for
a quick catnap.

When the snow falls,
Bolt and Keel head
to the mountains.
Their favorite trail
leads to a small cabin
nestled in the snow.

Home is where
your paws lead you.

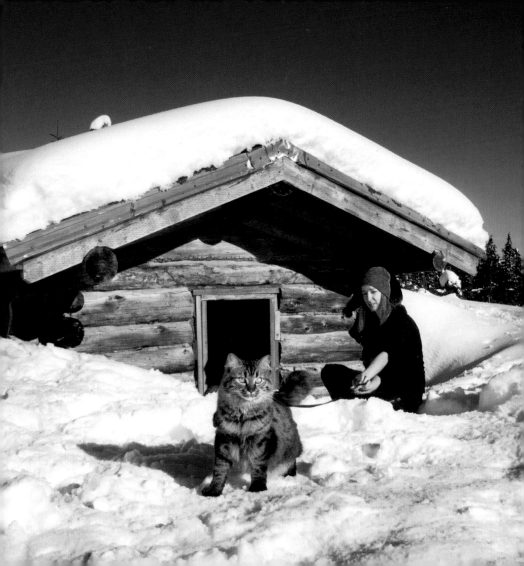

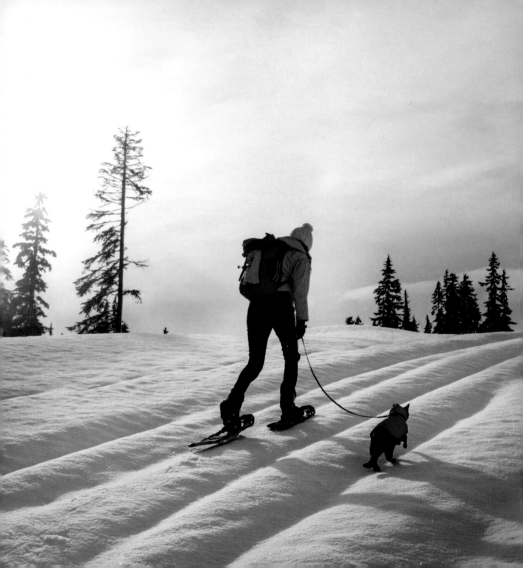

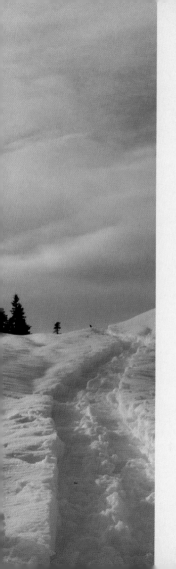

"THAT'S ONE SMALL STEP FOR HUMANS, ONE GIANT LEAP FOR CAT-KIND."

KEEL, ON NEIL ARMSTRONG

# Even adventure cats need breaks.

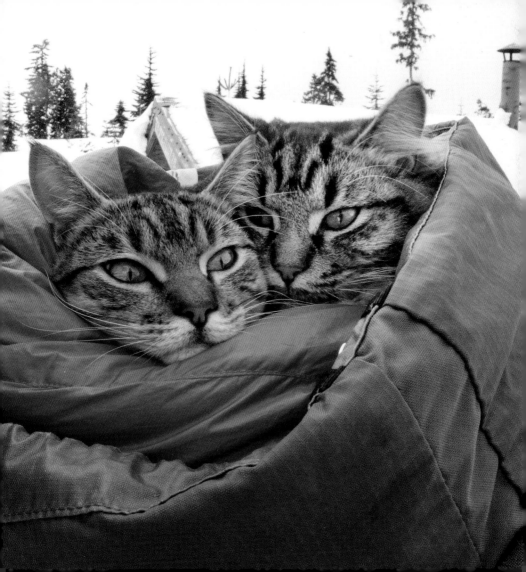

# "ANYONE WANT TO BRING ME BREAKFAST IN BED?"

KEEL

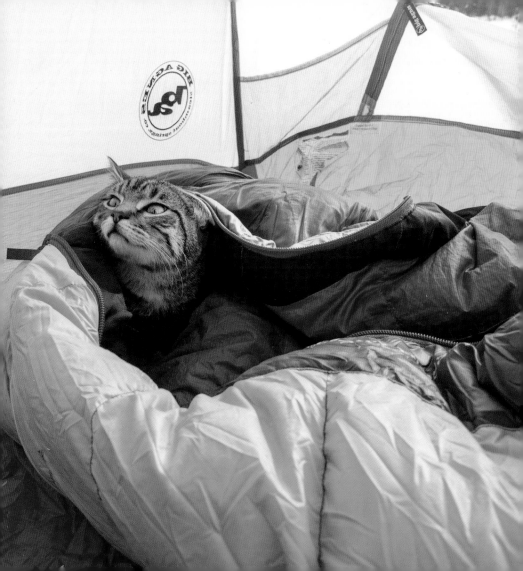

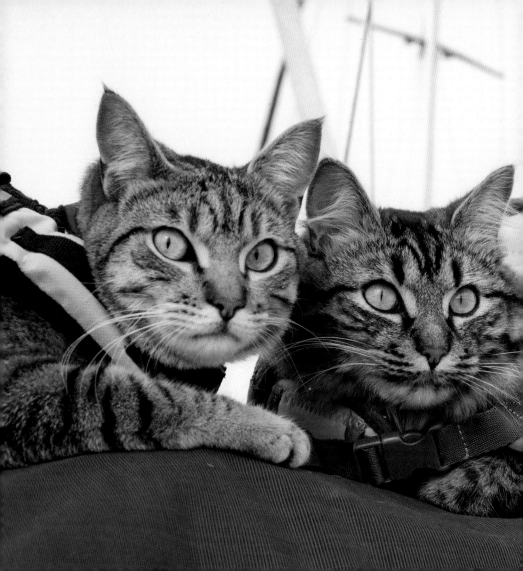

With life jackets on and a breeze in the air, Bolt and Keel join their humans on their first of many sailing trips through Vancouver Island's Inside Passage.

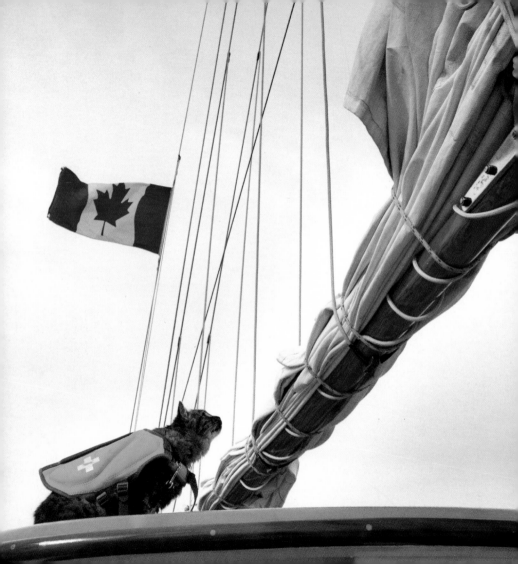

It's a lot easier to gain your sea legs when you have four of them.

# "WALK THE PLANK, YE OL' DOG."

### CAPTAIN BOLT

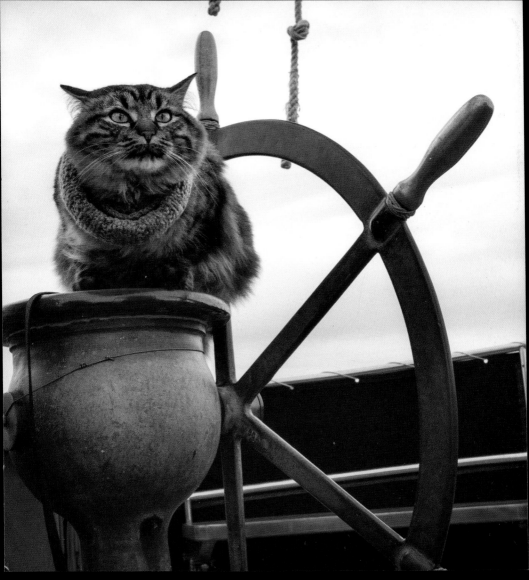

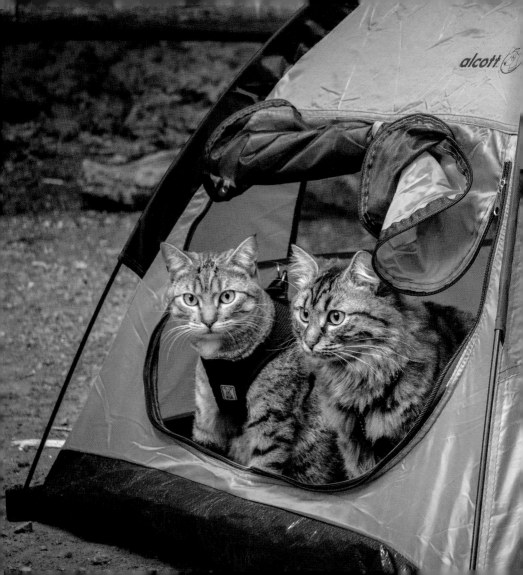

Protective of their new tent,
Bolt and Keel make up a
new rule: No dogs allowed.

**Fact:** Down sleeping bags make for #HappyCampurrs

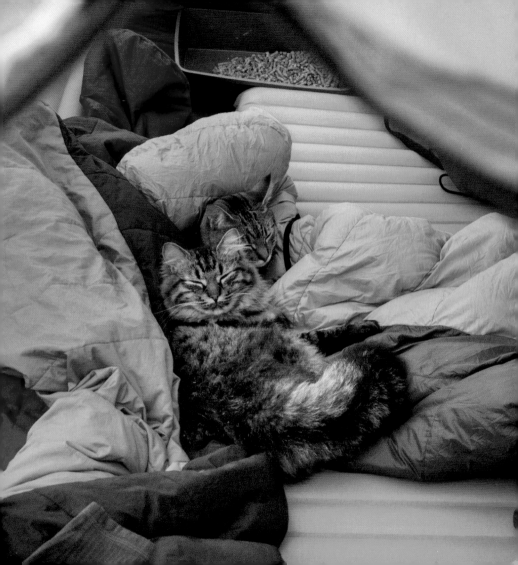

AVATAR GROVE, BC

Deep within the
British Columbia
rainforest, Bolt and
Keel go in search
of Canada's
Gnarliest Tree.

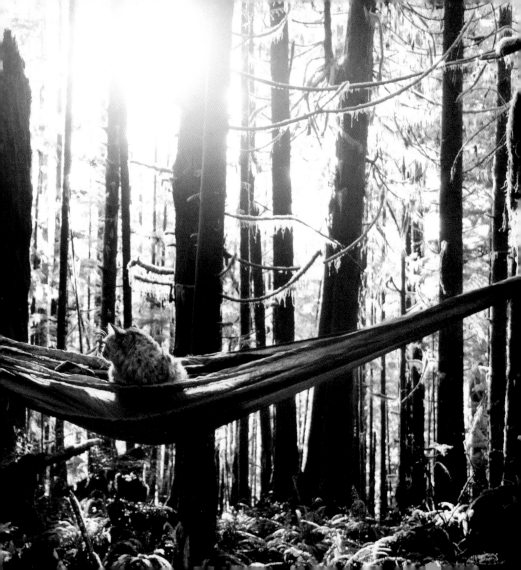

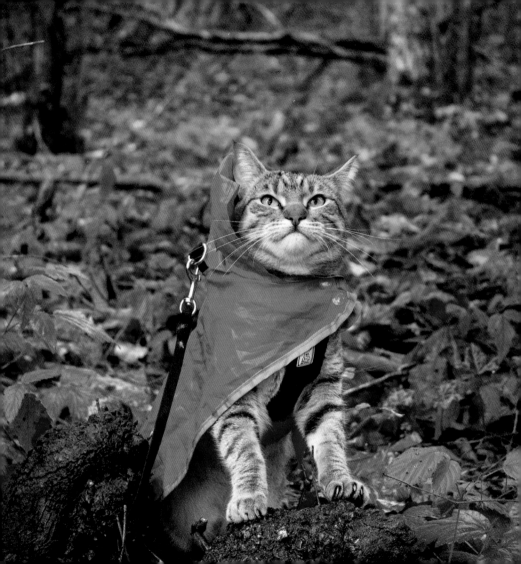

That feeling you get when you know you've been a good boy.

"I THOUGHT YOU SAID IT WAS GOING TO BE SUNNY TODAY!"

KEEL

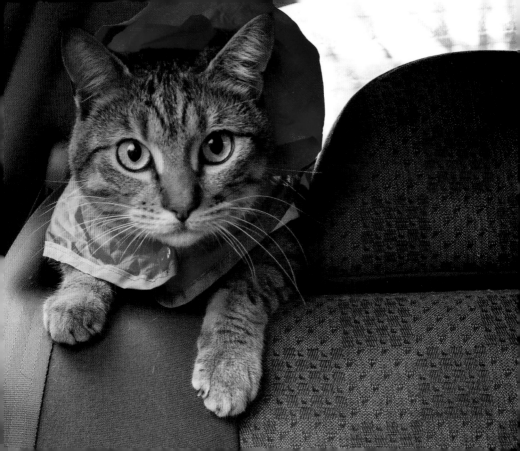

When there isn't time for a grand adventure, Bolt and Keel make the best of day trips canoeing on a local lake.

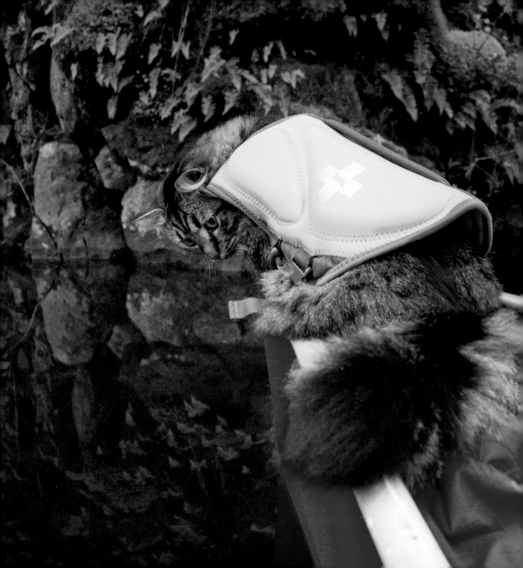

That face you make when you realize there's no turning back.

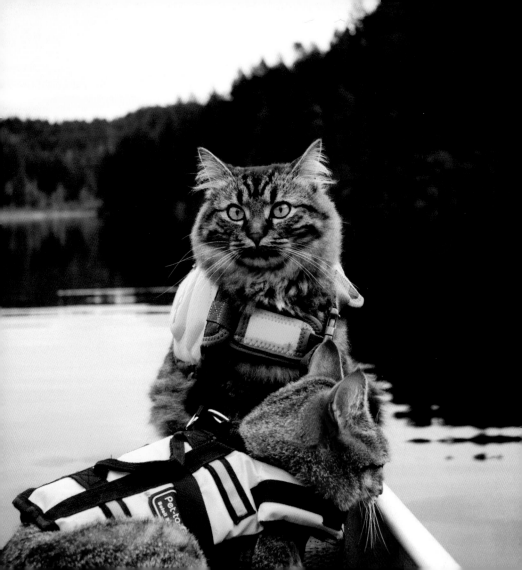

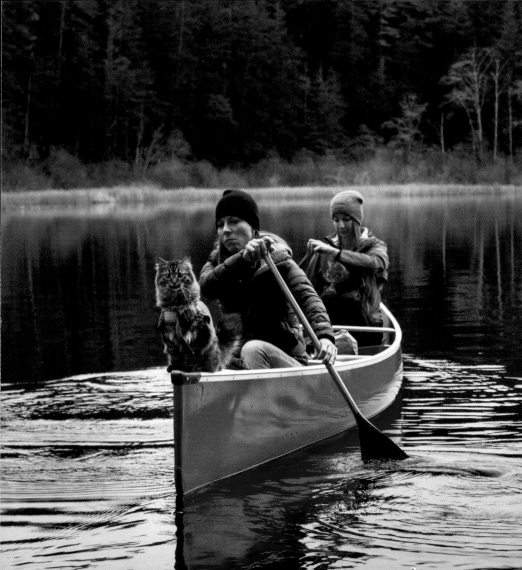

Two seconds before Bolt leaped
into the water . . .

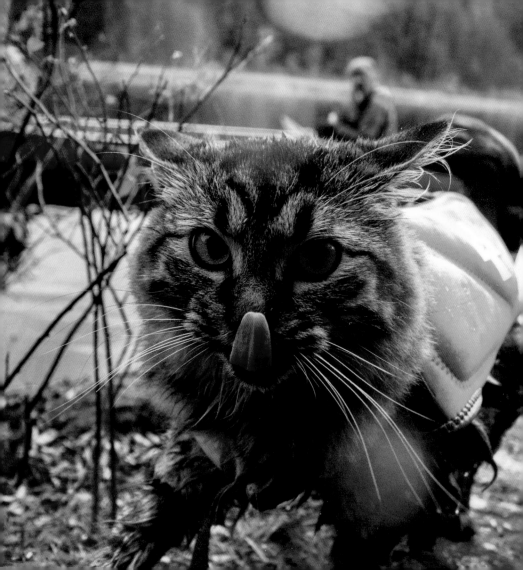

. . . two seconds after.

On a chilly fall day, Bolt and Keel tackled a new trail. The day was colder than most and they cuddled in the backpack for warmth on the way up.

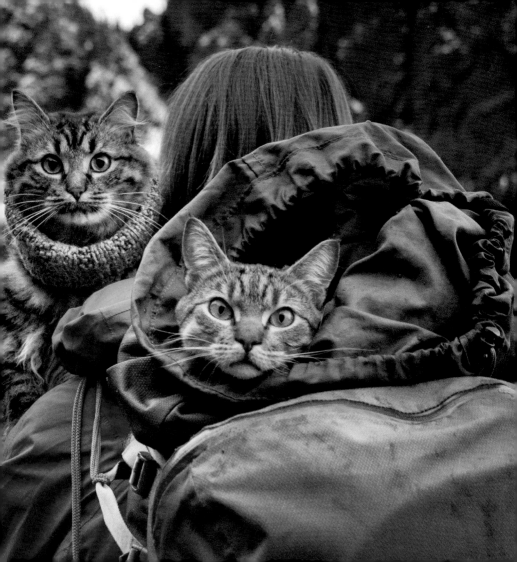

Good views are always
better with furriends.

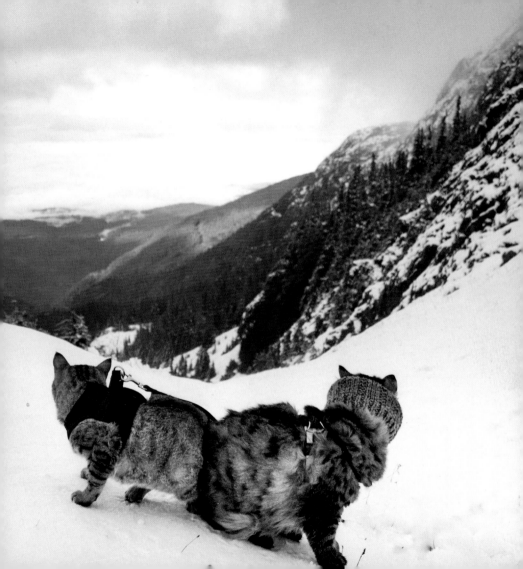

When you realize you've left
the TP in the car.

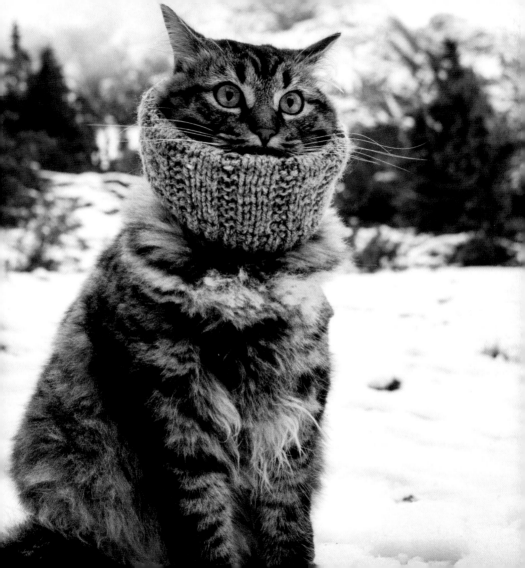

**Fact: Humans make excellent Sherpas.**
#AreWeThereYet

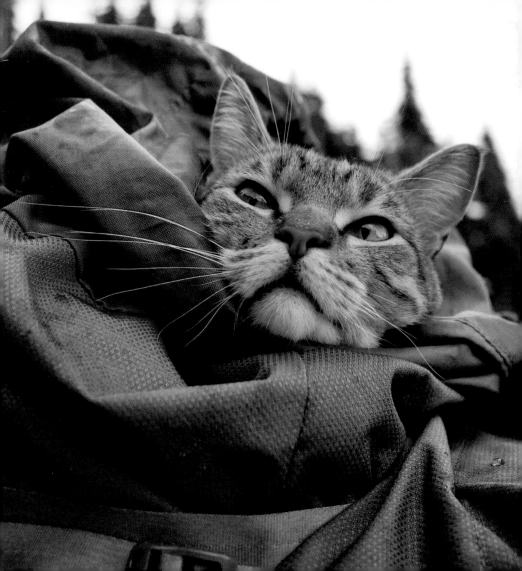

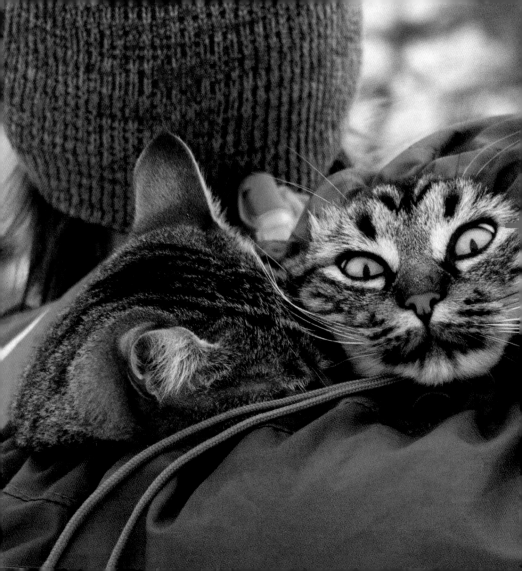

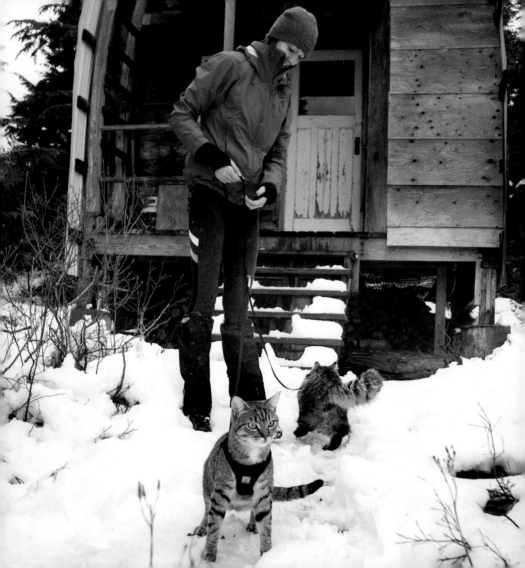

A snowy alpine hike means finding solace in a winter cabin hidden among the trees.

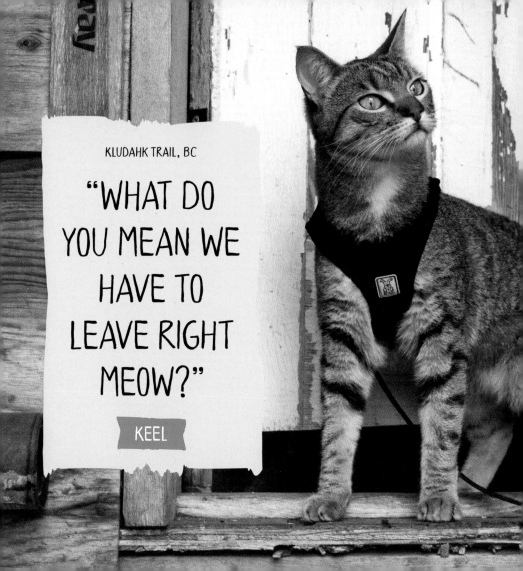

KLUDAHK TRAIL, BC

"WHAT DO YOU MEAN WE HAVE TO LEAVE RIGHT MEOW?"

KEEL

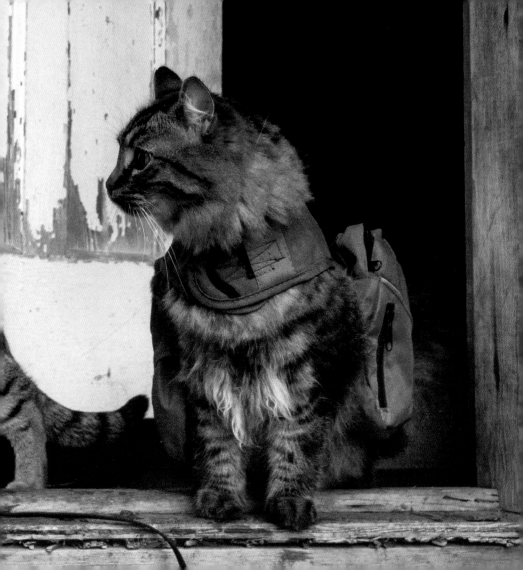

**Fact:** Fluffy cats make great face warmers.

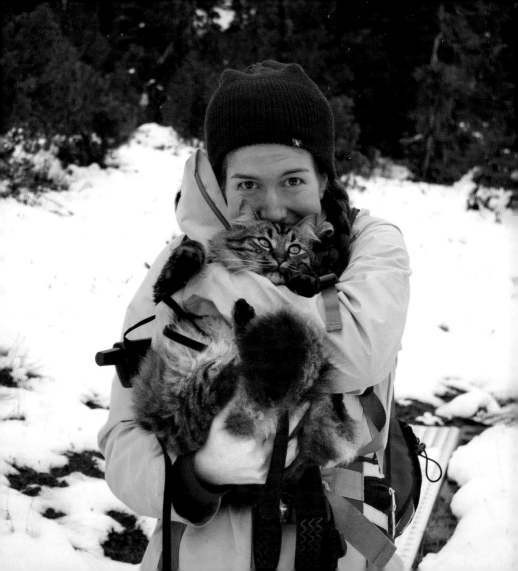

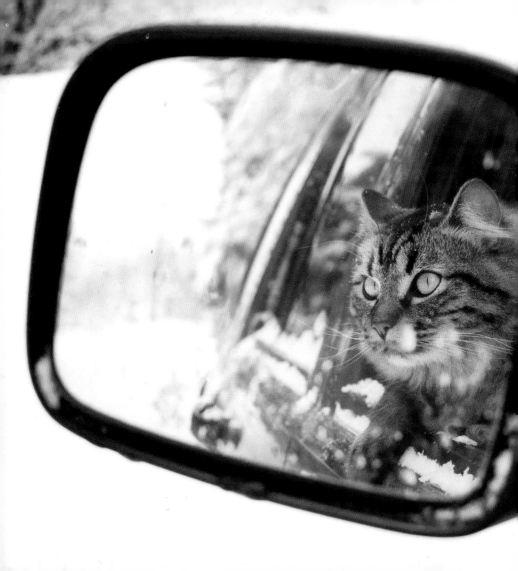

BELLINGHAM, WA

A long weekend
means time for a
road trip stateside.
Bolt and Keel
crossed the border
and ventured into
new territory.

A quick pit stop to explore the lush greenery and waterfalls of Bellingham before heading into a snowstorm.

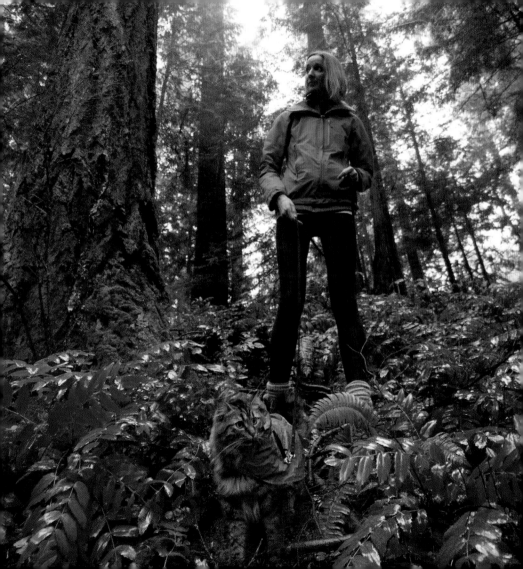

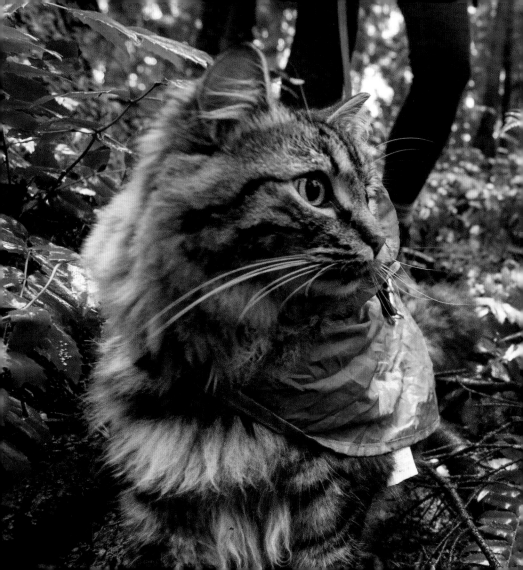

Bolt takes a moment to enjoy
the lush greens and misty air.

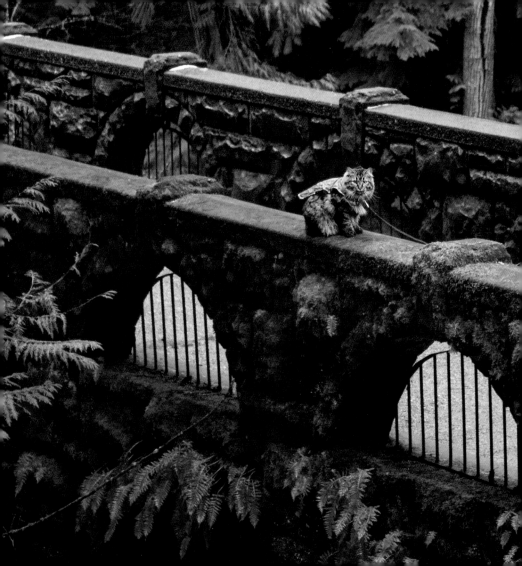

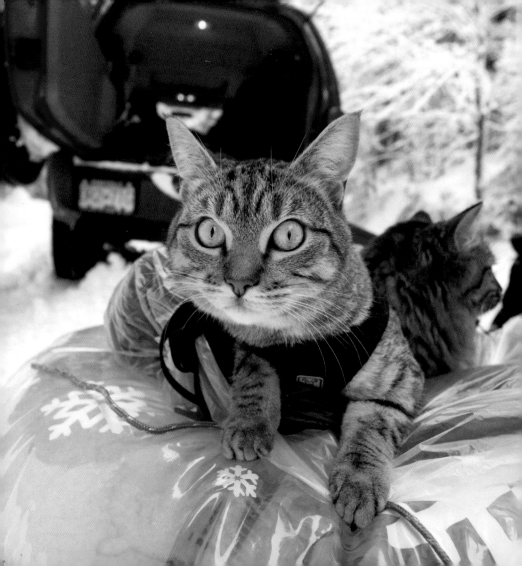

Being an adventure cat means being open to new modes of transportation. Bolt and Keel take on tobogganing!

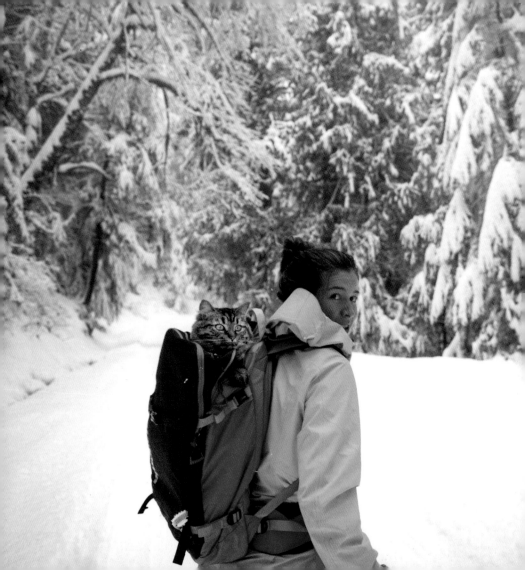

Wisdom from Bolt:
When your friend
offers you a lift,
don't think twice—
just take it.

After a three-day power outage
and heavy snowfall, Bolt and
Keel are now part snowcat.

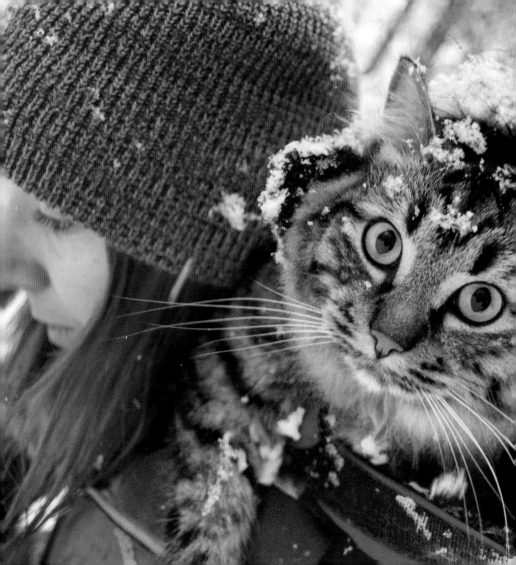

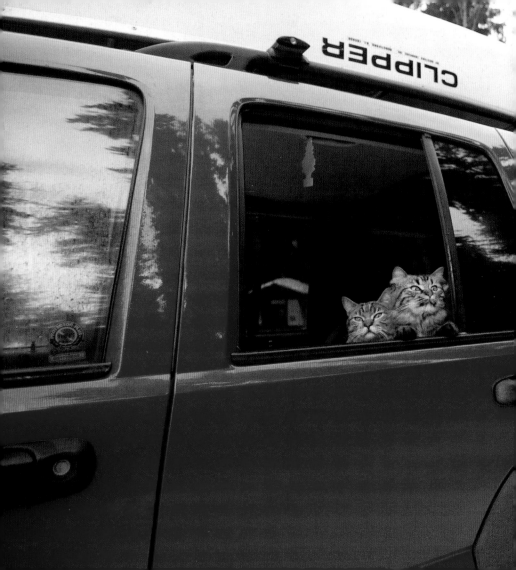

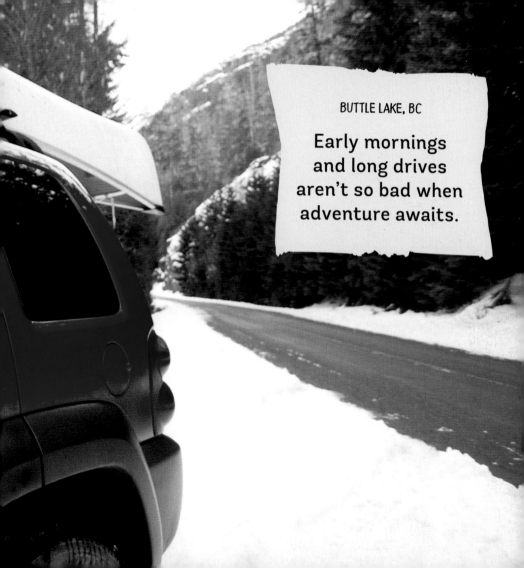

BUTTLE LAKE, BC

Early mornings
and long drives
aren't so bad when
adventure awaits.

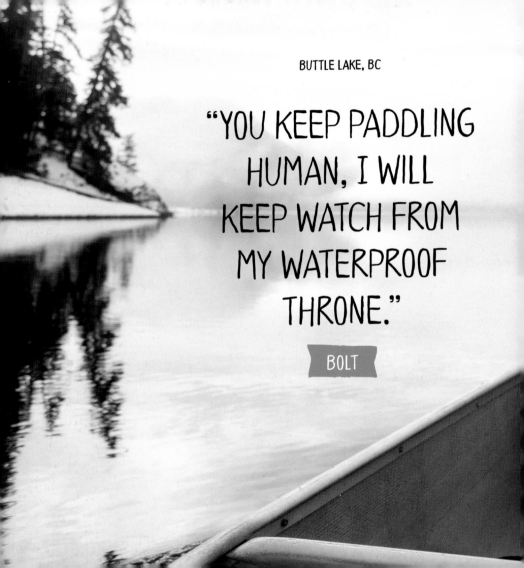

BUTTLE LAKE, BC

"YOU KEEP PADDLING HUMAN, I WILL KEEP WATCH FROM MY WATERPROOF THRONE."

BOLT

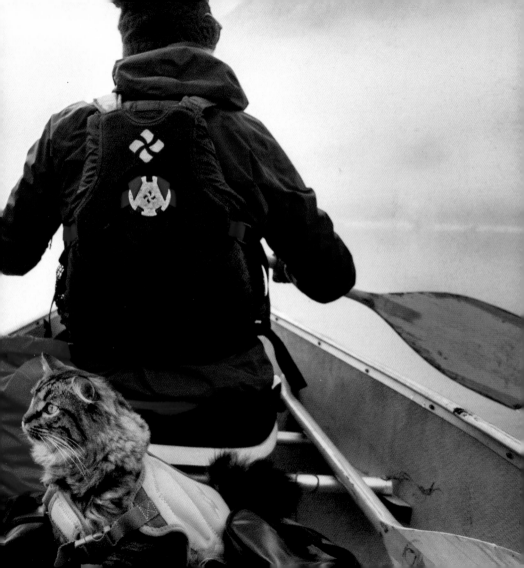

When life gives you a litter box
. . . take it with you.

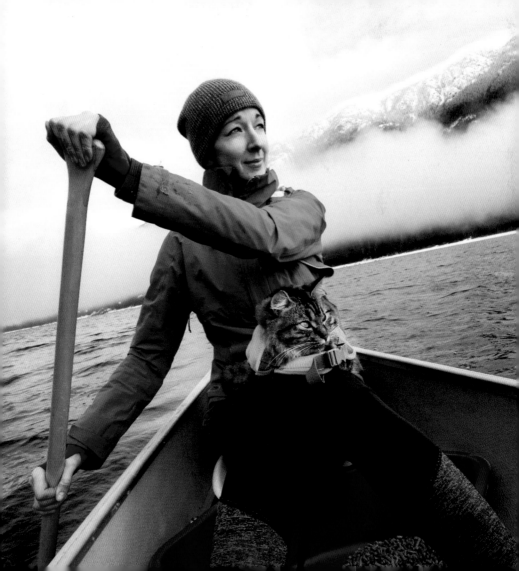

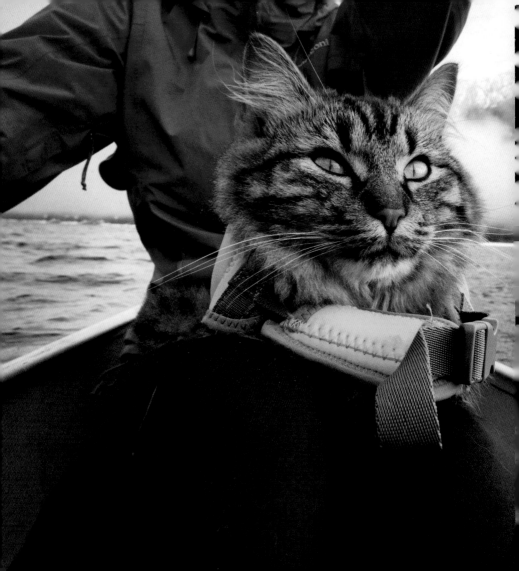

BUTTLE LAKE, BC

Being an adventure
cat means not
letting anything
hold you back.
#NoExcuses

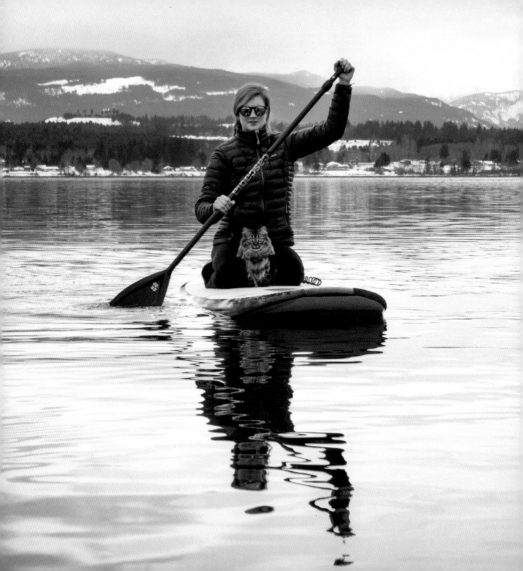

Breaking stereotypes,
one adventure at a time.

Sunshine Coast Trail

Inland Lake Provincial Park

Powell River

Mount Washington

Marble Meadows

GOLDEN HINDE

Buttle Lake

Comox

Strathcona Provincial Park

SALISH

VANCOUVER

MT. ARROWSMITH

Mount Arrowsmith

Triple Peak

ISLAND

PACIFIC

OCEAN

Avatar Grove

Kludahk Trail

MILES

0 5 10 15 20 25 30 35

BRITISH COLUMBIA

SEA

△
MT. ROBIE REID

■Vancouver

FRASER RIVER

CANADA

UNITED STATES

🐾 Glacier
MT. BAKER

🐾 Bellingham

🐾 Sidney

Victoria 🐾

🐾 Salish Sea
Mount Manuel Quimper

🐾 Matheson Lake Regional Park

WASHINGTON STATE

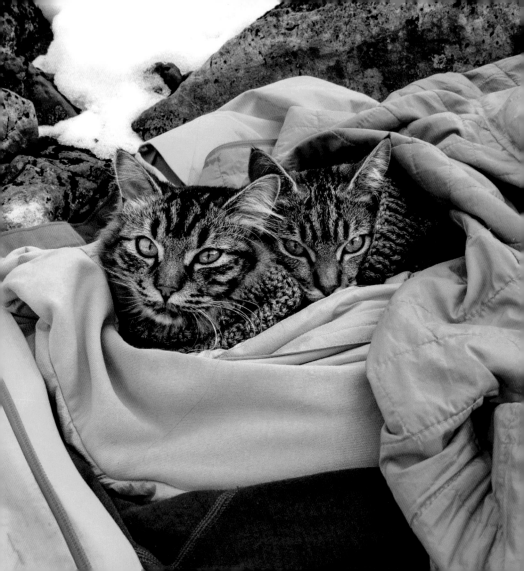

# QUICK TIPS FOR PHOTOGRAPHING YOUR CAT:

1. A high-speed shutter allows you to capture them in action.

2. Get on their eye level; see it from their purrspective.

3. Salmon treats always help!

## About the Authors

"KAYLEEN IS OUR PURRFESSIONAL PHOTOGRAPHER, MEDIA MANAGER, AND BOOKING AGENT. YOU CAN FIND HER BEHIND THE CAMERA OR TRYING TO KEEP UP ON THE OTHER END OF OUR LEASHES."

KEEL

"DANIELLE IS OUR PURRFESSIONAL POOPER SCOOPER, TREAT DISPENSER, AND PERSONAL SHERPA. YOU CAN FIND THE BACK OF HER HEAD IN MANY OF OUR PHOTOS AND WE CAN ALWAYS COUNT ON HER FOR EXTRA SNUGGLES."

BOLT

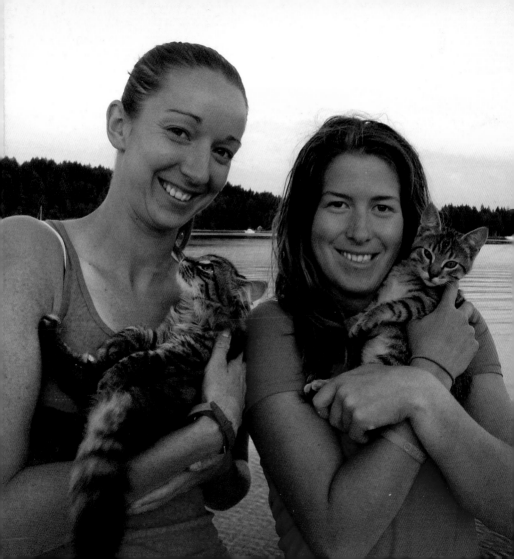

For information about permission to reproduce
selections from this book, write to Permissions,
The Countryman Press, 500 Fifth Avenue, New York, NY 10110

For information about special discounts for bulk purchases,
please contact W. W. Norton Special Sales at
specialsales@wwnorton.com or 800-233-4830

Manufacturing by Toppan LeeFung
Book design by Jackie Shao
Production manager: Devon Zahn

The Countryman Press
www.countrymanpress.com

A division of W. W. Norton & Company, Inc.
500 Fifth Avenue, New York, NY 10110
www.wwnorton.com

978-1-68268-120-6

1 0   9   8   7   6   5   4   3   2   1